P9-DFU-897

Volume II

SON
— OF —
MAN

MIRACLES OF JESUS

To my children for their love and support.

—LIZ LEMON SWINDLE

To my grandson, Jack, for teaching me
that miracles are still possible.

—SUSAN EASTON BLACK

Volume II

SON
OF
MAN

MIRACLES OF JESUS

by Susan Easton Black

Artwork by Liz Lemon Swindle

The Greenwich Workshop Press
Seymour, Connecticut

A GREENWICH WORKSHOP PRESS BOOK

Copyright ©2003 by The Greenwich Workshop Press
All art ©Liz Lemon Swindle

All rights reserved. No part of this book may be reproduced, altered, trimmed, laminated, mounted or combined with any text or image to produce any form of derivative work. Nor may any part of this book be transmitted in any form or by any means, electronic or mechanical, including photocopying and recording, or by any information storage and retrieval system, without permission in writing from the publisher.

Published by the Greenwich Workshop, Inc., 151 Main St., P.O. Box 231, Seymour, CT 06483. (203) 881-3336 or (800) 243-4246.

Library of Congress Cataloging-in-Publication data is available from the publisher upon request.

The author and publisher have made every effort to secure proper copyright information. In the event of inadvertent error, the publisher will be happy to make corrections in subsequent printings.

Limited edition fine art prints and canvas reproductions of Liz Lemon Swindle's paintings are available exclusively through The Greenwich Workshop, Inc., and its 1,200 dealers in North America. Collectors interested in obtaining information on available releases and the location of their nearest dealer are requested to visit our website at www.greenwichworkshop.com or to write or call the publisher at the address to the left.

FOR FURTHER READING

The Holy Bible containing the Old and New Testaments. Authorized King James Version. Translated out of the original tongues and with the former translations diligently compared and revised by His Majesty's special command.

J.R. Dummelow, ed., *A Commentary on the Holy Bible* (New York: Macmillan Company, 1964).

Alfred Edersheim, *Jesus the Messiah: An Abridged Edition of the Life and Times of Jesus the Messiah* (Grand Rapids, Michigan: Wm. B. Eerdmans Publishing Company, 1976).

Ralph Gower, *The New Manners and Customs of Bible Times* (Chicago, Illinois: Moody Press, 1987).

National Geographic Society, *Everyday Life in Bible Times* (National Geographic Society, 1967).

Wolfgang E. Pax, *Footsteps of Jesus* (Jerusalem, Israel: Nateev Publishing, 1970).

Hayyim Schauss, *The Jewish Festivals: A Guide to Their History and Observance* (New York: Schocken Books, 1938).

James E. Talmage, *Jesus the Christ* (Salt Lake City, Utah: Deseret Book Co., 1983).

Jacket front: *Against the Wind*
Book design by Scott Eggers Design, Salt Lake City
Printed in China
First Printing 2003

ISBN 13: 978-0-86713-087-4

4 5 6 09 08

CONTENTS

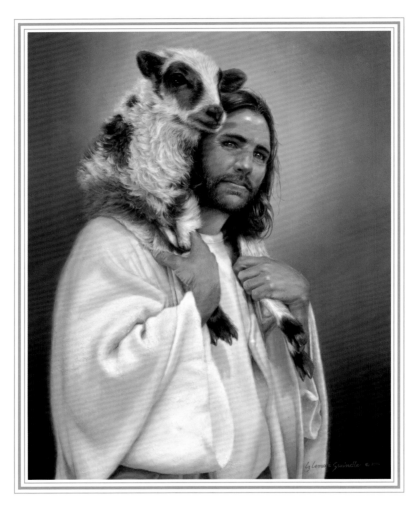

THE LOST SHEEP

As with every life, there comes a time when the Master's touch is needed. For me, that time came when a newborn grandson's life hung in the balance. For Liz, it came when her son Bryun was diagnosed with a brain tumor. Both of us, dearest friends, wondered aloud where we could turn for peace? Where was our solace? The clear and unmistakable answer received by both of us was Jesus, the miracle worker of Galilee. ¶ By his healing touch the blind saw, the lame walked, and the leprous became clean. "Whithersoever [Jesus] entered, into villages, or cities, or country, they laid the sick in the streets, and besought him that they might touch if it were but the border of his garment: and as many as touched him were made whole." ¶ We felt to ask with the faithful centurion, "Lord, I am not worthy that thou shouldest come under my roof: but speak the word only, and my servant shall be healed." Would he answer? Would the Good Shepherd, who watched over and cared for the lambs in Judaea, be mindful of our loved ones? In humble gratitude, we announce that the miracles recorded in yesteryears are not that far distant. His infinite care and miraculous power are felt today. We rejoice in the miracles of antiquity, and humbly acknowledge the miraculous blessings that have occurred in the lives of our loved ones. With deep appreciation, we present Miracles of Jesus.

— Susan Easton Black

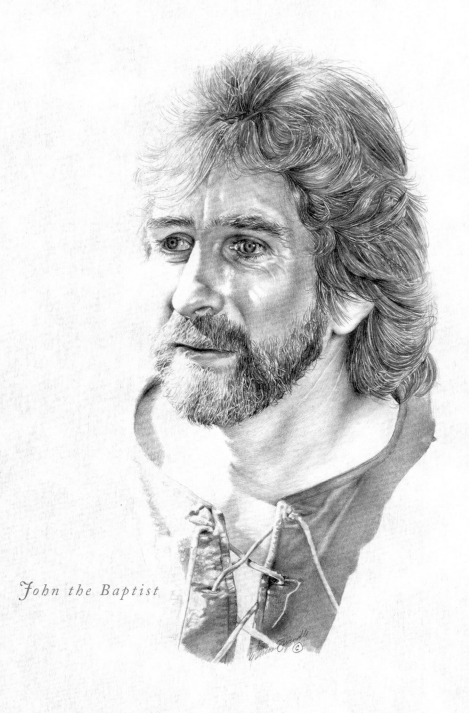

John the Baptist

ONE MIGHTIER THAN I

IN a society where class distinction, fine-twined linen, and a self-serving embrace of the sacred were all too apparent, a lone voice was heard speaking of something higher, something greater. John the Baptist began preaching in the wilderness of Judaea far from the soft garments and flowing robes of the Jerusalem aristocracy. "Repent" was his clarion cry; Turn from the blatant ills of the Palestinian society, his urgent plea; Embrace the sacred—the covenants between Jehovah and the Fathers of Israel, his pressing invitation.

John knew that the time had come for all men to rise above societal expectations. "Prepare ye the way of the Lord," he called. His message was timely and as sure as its divine source. Faithful throngs gathered to listen. Many accepted his words and cast aside their evil ways to enter the baptismal waters of Bethabara. They did so with the assurance that they were not merely imitating a ritualistic cleansing sanctioned by the Mosaic law. Nor were they following the way of a Gentile to become a proselyte of righteousness. These faithful converts knew that their baptism demonstrated before Jehovah a willingness to make and keep sacred covenants and to begin preparing the way for the ministry of the Son of God.

Yet in their willing conformity, they did not understand the role John the Baptist played in the Kingdom of God. "All men mused in their hearts of John." Was he the Christ? The prophesied Messiah? The Wonderful, Counsellor, the Mighty God? or "should they look for another?" Without equivocation, John stated, "One mightier than I Cometh." The high stature of Jesus in the Kingdom of God caused John to portray himself as "not worthy to unloose" the lachet of his Master's sandal. Although John was greater than all the prophets of antiquity, the "One mightier that cometh" would be greater than them all. For "he shall baptize you with the

THE BAPTISM OF JESUS

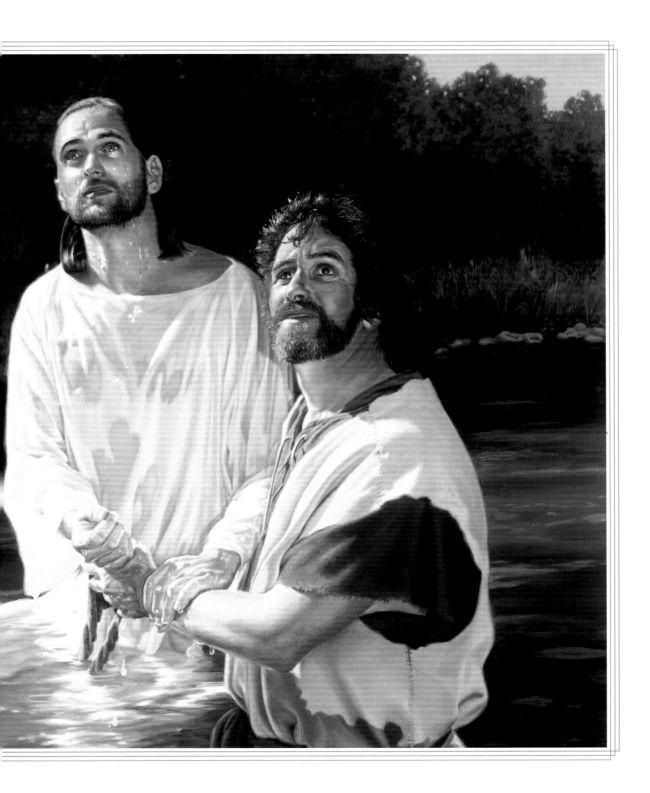

Holy Ghost and with fire," John prophesied.

Then one day, as John the Baptist was standing in the Jordan River—a river that flows through the deepest valley in the world as it meanders along its destined route to the Dead Sea—there came a carpenter's son from Nazareth seeking baptism. Although many may have thought of him as a commoner from a small village, John did not. He knew that Jesus was no ordinary son of a laborer; he was the Son of God, the promised Messiah. "I have need to be baptized of thee," said John, recognizing Jesus' divine Sonship. But Jesus replied, "Suffer it to be so now: for thus it becometh us to fulfill all righteousness." So John baptized the Messiah, the Son of Man, the Mighty One of Israel.

Jesus descended in the river, beneath all things, to enter into the humble baptismal covenant. And on that day of days "Jesus, when he was baptized, went up straightway out of the water: and, lo, the heavens were opened unto him, and he saw the Spirit of God descending like a dove, and lighting upon him." He heard a voice from Heaven, even the voice of God the Father saying, "This is my beloved Son, in whom I am well pleased." Recognizing his voice and wanting to commune with his Father and "being full of the Holy Ghost, Jesus was led by the Spirit into the wilderness" of Judaea. For forty days and nights, he fasted and worshipped God in the desert terrain. As his fast ended, he hungered.

Seeking to appeal to Jesus' carnal appetite, the arch-enemy of all righteousness attempted to divert him from his prophesied mission. "If thou be the Son of God, command that these stones be made bread," Satan said. To any but the Savior, Satan's appeal to the carnal would have been enticing, but to one who had communed with his Father for forty days, the appeal lacked luster. "Man doth not live by bread only, but by every word that proceedeth out of the mouth of the Lord," Jesus replied. A second temptation followed: "If thou be the Son of God, cast thyself down: for it is written, He shall give his angels charge concerning thee: and in their hands they shall bear thee up, lest at any time thou dash thy foot against a stone." Jesus answered, "Thou shalt not tempt the Lord thy God." A third temptation with the luring promise of riches and power was hurled at Jesus: "All these things will I give thee, if thou wilt fall down and worship me." Jesus did not succumb to these satanic promises, for his path was straight and his course toward eternity sure. He was the chosen Savior, the Christ, and he knew at that very hour that the time for his earthly ministry had come.

He left the wilderness of Judaea to raise his voice in sweet Galilee. Along the harp-like shoreline of the

And there were set there
six waterpots of stone, after
the manner of the purifying
of Jews, containing two
or three firkins apiece.

Jesus saith unto them,
Fill the waterpots with
water. And they filled them
up to the brim.

And he saith unto them,
Draw out now, and
bear unto the governor
of the feast. And they
bare it.

When the ruler of the feast
had tasted the water that was
made wine, and knew not
whence it was; (but the
servants which drew the
water knew;) the governor
of the feast called the bridegroom,

And saith unto him,
Every man at the beginning
doth set forth good wine;
and when men have well drunk,
then that which is worse: but
thou hast kept the good wine until now.

This beginning of miracles
did Jesus in Cana of Galilee,
and manifested forth
his glory;
and his disciples believed on him.

John 2: 6-11

Sea of Galilee, Jesus spoke of repentance. Rejecting evil ways was not a new theme to his listeners—they had heard it from John the Baptist—but his central message, "The kingdom of heaven is at hand," was new. In those precious words, he announced that the preparatory years had passed; the Messiah now walked among men.

"Come follow me," he invited, so simple, yet sublime. Straightway, Andrew and Simon left their fishing nets, and followed him. James and John "immediately left [their] ship and their father, and followed him." The invitation of Jesus to Philip of Bethsaida added yet another disciple. Philip, in turn, spoke to Nathanael, "We have found him, of whom Moses in the law, and the prophets, did write, Jesus of Nazareth, the son of Joseph." Fishing boats were put to rest on the shoreline, vocations that had passed from father to son were abandoned, and the cares of the world were set aside as men left the temporal to become disciples of Jesus.

Jesus and his disciples first journeyed together to Cana for a wedding feast. Perhaps the Master and his new disciples arrived at Cana in time to assist the groom in searching for his bride. With lighted lamps raised high and vials of oil hanging from their arms, they may have scoured the countryside in search of the favored woman. They may have seen the groom remove the wedding veil from his bride's face and lay the veil upon his shoulder. They may have heard the villagers exclaim, "The government shall be upon his shoulder," meaning the government for starting a new family was upon him. As the groom and his bride led a festive procession to their home, perhaps Jesus and his disciples were among those making merry sounds or waving flowers or myrtle branches in joyous expression of the union between man and woman. After hearing the words, "Take her according to the Law of Moses and of Israel," they may have encircled the festive couple as they were crowned with garlands under the wedding canopy.

We do not know whether Jesus and his disciples participated in the traditional elements of the Galilean wedding. But there is no question that they attended the marriage feast. During the festivities, wine was served. Although water was a precious commodity to desert travelers, fruit of the vine was traditionally given to satisfy wedding guests. As the festivities progressed, guests drank freely until the goat carcasses, which had served as wine bags, were empty.

Mary "the mother of Jesus," observing that the guests had depleted the wine vessels, "saith unto [her son], They have no wine." To be without the fruit of

the vine at the wedding festivities was to bring misfortune to the marriage and to disrupt the protocol in Galilee that demanded guests quench their thirst with wine until the festivities had ended.

"Woman, what have I to do with thee?" was Jesus' query to his mother. Although today his words seem impersonal if not insensitive to the social situation, such was not the case in Cana. Anciently, to be called woman was a mark of honor and respect, for "to every son his mother was preeminently the woman of women." Jesus did not excuse himself from fulfilling her request, but he gently reminded his mother, "Mine hour is not yet come." The sacrificial hour he was referring to was the sacred hour in which he would offer himself as a ransom for the sins and sorrows of the world. That hour was reserved for the culmination of his ministry, not the beginning. The beginning hours were to be this day in Cana at the wedding feast. They were to begin with the miracle of water being turned to wine. Jesus of Nazareth, who had refused to appease his own carnal appetite in the Judaean wilderness, now willingly answered his mother's request by providing wine for the wedding guests whose thirst was momentary.

"Fill the waterpots with water," he instructed the household servants. It was the ceremonial purification pots that were needed on this occasion, not the empty goatskin bags that had once covered a goat's neck and torso. Jesus did not want to case his new wine— a symbolic reference to the gospel from the True Vine—in the old, stretched skin of Judaism that had become brittle with age. The servants, unaware of the divine symbolism or the fact that ceremonial pots would become receptacles of wine, filled them to the brim with water.

"Draw out now, and bear unto the governor of the feast," Jesus instructed them. As the servants did so, it was not water that was given to the governor but wine. "When the ruler of the feast had tasted the water that was made wine, and knew not whence it was: (but the servants which drew the water knew) the governor of the feast called the bridegroom." The governor said to the groom, "Every man at the beginning doth set forth good wine; and when men have well drunk, then that which is worse: but thou hast kept the good wine until now."

Although the governor was the first to speak of a miracle of Jesus, he was not the first to recognize Jesus of Nazareth as a miracle worker. The governor simply thought that the good wine had been reserved until the end of the festivities. It was the followers of Jesus, the simple fisherman from Galilee, who were the first to acknowledge that in this miracle Jesus had "manifested

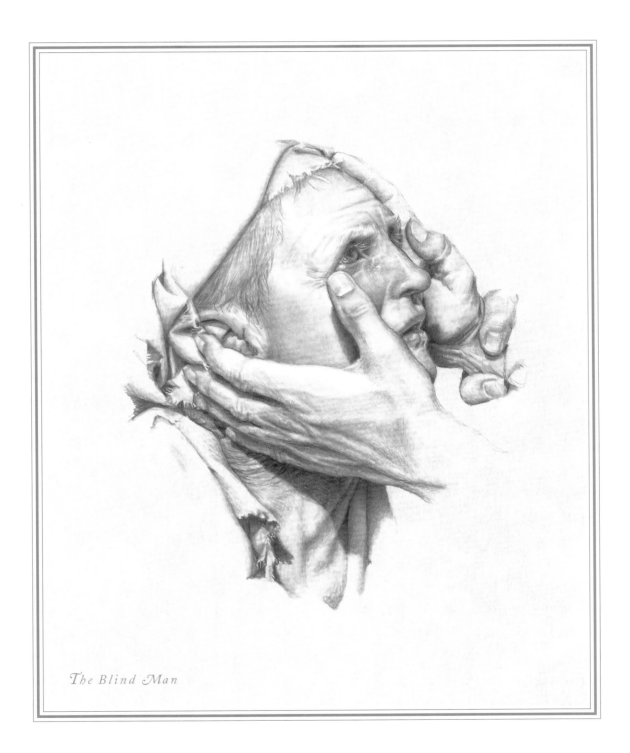

The Blind Man

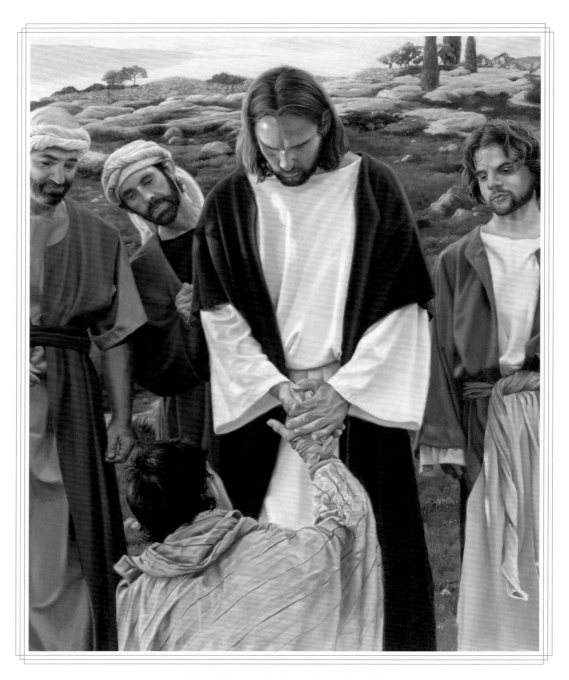

WHERE ARE THE NINE?

forth his glory; and his disciples believed on [Jesus]."

Other miracles soon followed as the Master and his disciples ventured forth upon the byways and into the villages near the Sea of Galilee. Like the governor at the feast, the recipients of Jesus' miracles did not always recognize the miracles nor the true identity of Jesus of Nazareth. Although many were cured of life-long maladies and afflictions, they could only reply as the blind man, "Whereas I was blind, I now see." They knew that the stigma of sin that the Jewish culture had associated with their illness or accident was gone from their lives forever, but few realized that it was the Son of God who had provided this merciful blessing. While most praised Jehovah for the miracles in their lives and hurried to spread the fame of Jesus of Nazareth throughout the region, others discounted his miracles. Some acknowledged Jesus as a miracle worker, but still looked for another to be the Mighty One of Israel, the Messiah who would bring peace to the earth.

However, their looking beyond the Man did not prevent them from seeking him out at every turn. "And there was a certain nobleman, whose son was sick at Capernaum. When he heard that Jesus was come out of Judaea into Galilee, he went unto him, and besought him that he would come down, and heal his son: for he was at the point of death." Jesus saith unto him, "Go thy way; thy son liveth." And the man believed the word that Jesus had spoken unto him, and he went his way and the son did live. When "Jesus was come into Peter's house, he saw his wife's mother laid, and sick of a fever. He touched her hand, and the fever left her." When a centurion informed him that a "servant lieth at home sick of the palsy, grievously tormented," Jesus replied, "Go thy way; and as thou hast believed, so be it done unto thee. And his servant was healed in the selfsame hour."

These miracles along with a myriad of unrecorded healings led many to question, "What thing is this? What new doctrine is this?" They lived in a community that accepted only limited medicinal practices, not the miraculous healings that were changing their Galilean society one person at a time. For centuries they had used traditional, natural remedies to heal the sick. These remedies had been passed from generation to generation. Such herbs as mustard seed, mint, rue, anise, dill, and cumin were used to heal an assortment of ills. They were as acceptable and commonplace as applying wine to disinfect wounds and oil to sooth abrasions. The physician's scalpel was also accepted, but only after traditional remedies failed. If a scalpel was needed, Galileans sought a Greek physician whose reputation was respectable, but they questioned

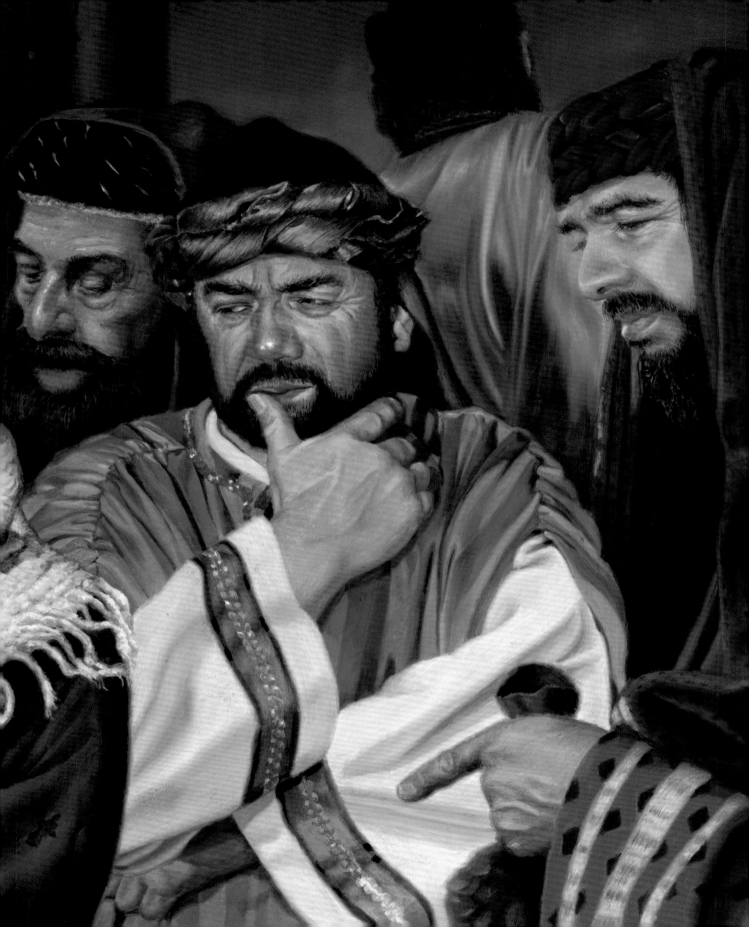

the ability of Romans and even kindred. Cultic healings were too secretive and objectionable for the typical Galilean. Most people frowned upon magic potions, wizardry, secret herbs, and incantations to awaken the spirit world.

There was one option that the Galilean society reserved for the unexplainable medical cure—the miracle worker. Surely Jesus had not used traditional remedies in the healing of the centurion's servant or a scalpel on Peter's mother-in-law. To suppose that an incantation was used to cure the centurion's servant was ludicrous. Therefore, the only plausible explanation of his healing power was that Jesus of Nazareth was a miracle worker. But unlike the self-proclaimed miracle workers in Judaea, Jesus cured all those within his reach, even the ungrateful and the sinner.

"How was this possible?" men along the shoreline asked. Although the Galileans lacked the answer, it does not appear that they were hesitant to bring ailing loved ones to the Master. "They brought unto him all sick people that were taken with divers diseases and torments, and those which were possessed with devils, and those which were lunatick, and those that had the palsy; and he healed them." When we see Jesus as the doer of these miracles, it seems rational to surmise that all looked to him as a miracle worker and praised Jehovah for his deeds. Such was not the case.

Among the many who witnessed his miracles were scribes of the Torah, men who prided themselves on their understanding of the legalities of Jewish law. They boasted that they were guardians and interpreters of the law, and that they had created commentaries in which the deeper meanings in the books of Moses were addressed. As respected interpreters of the law of Moses, scribes felt confident in judging the miracle worker of Galilee, the man who brought sight to the blind and hope to the downtrodden. In their self-righteous judgment, they accused Jesus of Nazareth of blasphemy—the greatest sin against their religious beliefs.

Although their accusation appears without basis, unbelievable when hurled at the Son of God, scribes found support for their position in their constricted view of Sabbath day observance. On the Sabbath day, when devout Jews worshipped Jehovah and sought to remember his goodness towards them, Jesus was seen relieving the sick of their affliction. In the minds of the scribes, such merciful help was outside the realm of acceptable Sabbath day observance. Just as gathering kindling, extinguishing a fire, giving an emetic, and setting a broken bone were forbidden on the Sabbath, so was any type of compassionate or merciful healing.

Jesus challenged their constrictive definition of Sabbath observance by stating, "The sabbath was made for man, and not man for the sabbath. The Son of man is Lord also of the sabbath." He then proceeded to prove his point. Just as he had performed miracles on the other six days of the week, he now healed on the Sabbath. A man with a withered hand, another who suffered from dropsy, and still another who was blind were all made well on that holy day. Even the request for health of a "certain man at the twin pools of Bethesda," who had suffered from an infirmity for thirty-eight years was not denied on the Sabbath. "When Jesus saw him lie, and knew that he had been now a long time in that case, he saith unto him, Wilt thou be made whole? . . . Rise, take up thy bed, and walk. Sin no more, lest a worse thing come unto thee." The man complied and was healed on that day.

"Blasphemy!" was the accusatory cry of the pious scribes. To these interpreters of the Mosaic law, giving credit to Jehovah for a healing on the Sabbath was a grave offense. To them, Jesus had violated the Sabbath

Jesus challenged their constrictive definition of Sabbath observance by stating, "The sabbath was made for man, and not man for the sabbath."

and was therefore numbered with sinners, harlots, and publicans. Their ridged, accusatory stance was loud and attracted Pharisees, Sadducees, and Herodians. These men "sought to slay [Jesus], because he had done these things on the sabbath day." But they exercised no influence on the humble Galileans. In fact, Galileans in ever greater numbers walked with the Master. They continued to be "amazed, and [they] glorified God."

Few details remain of those who suffered and received the blessing of health. Little is known of the man cured of dropsy. Even less is known of the lame, halt, and blind. For example, "Then was brought unto him one possessed with a devil, blind, and dumb: and he healed him, insomuch that the blind and dumb both spake and saw." Although an interesting account, scant details leave most gospel readers wanting more.

Though the gospel readers may know little of palsy, they recount this gospel story as if it happened yesterday: "And, behold, men brought in a bed a man which was taken with palsy: and they sought means to bring him in, and to lay him before [Jesus]. And

when they could not find by what way they might bring him in because of the multitude, they went upon the housetop, and let him down through the tiling with his couch into the midst before Jesus." And when the Master saw their faith, he said to the man afflicted with palsy, "Man, thy sins are forgiven thee. Arise, and take up thy couch, and go into thy house." Immediately, the man arose and picked up his bed, and "departed to his own house, glorifying God."

Modern day gospel readers repeat the story of the leper, a man who was shunned for his physical deformities and cast out of villages for his perceived uncleanness. With obvious emotion in their voices, they recall how he humbly approached Jesus in his clothes of mourning and uncovered head, which evidenced his earthly woes. Did he reach an advanced stage of the dreaded disease, where fingernails loosen and drop off, gums are absorbed, and the teeth decay and fall out? Such is not known, but his faith is

Jesus "put forth his hand," and touching him said, "Be thou clean, and immediately the leprosy was cleansed."

known. "Lord, if thou wilt, thou canst make us clean," he stated. Jesus "put forth his hand," and touching him said, "Be thou clean, and immediately the leprosy was cleansed."

Many other stories of casting out demons and healing the sorely vexed follow, but they too lack the detail that readers so want. It is the exception, the known, the detailed accounts of his miraculous healings that have riveted generations and led many to sing praises in adoration to the miracle worker of Galilee. In praise of his deeds, gospel stories are told again and again. Listeners enjoy the stories and often express a heart-felt longing to have lived in Galilee and to have known the Master's touch. They fancy themselves being lifted from their bed of affliction with the palsied and rejoicing at a newness of life with the leper. As the gospel story unfolds, they find themselves joining a generational chorus of believers who testify that Jesus, the miracle worker of Galilee, is the Messiah.

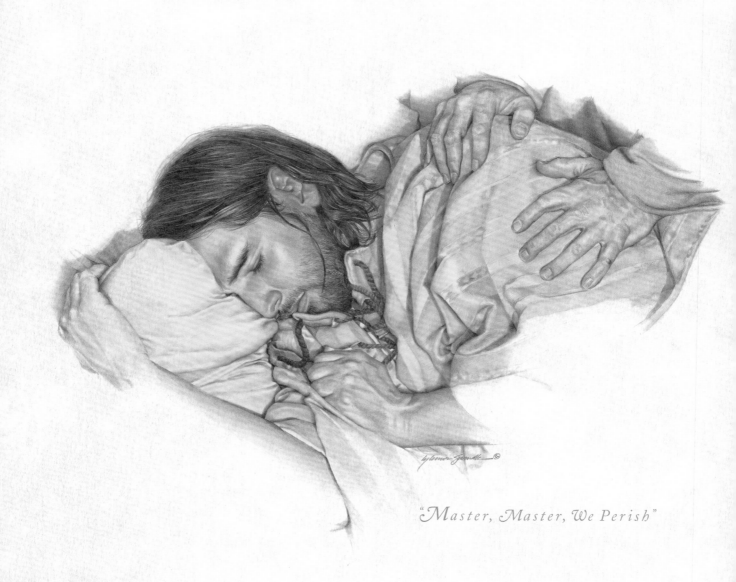

"Master, Master, We Perish"

THOU ART
THE CHRIST

O N A CERTAIN DAY," Jesus and his disciples boarded a vessel harbored near the shoreline of Galilee. "Let us go over unto the other side of the lake," said Jesus to his companions. None opposed his suggestion, so "they launched forth" setting sail for the distant shore—the Gadarenes countryside. As they sailed "there came down a storm of wind on the lake." The turbulence probably, caused by heavy rainfall and easterly winds, disturbed the placid waters of the Sea of Galilee. The waves,

once gentle and rippling, now soared like the high seas and frightened fishermen and disciples alike. Yet Jesus slept, undisturbed by the pitching sea as if the waters were calm. Though all others aboard feared that their craft was in jeopardy from the heaving waters, Jesus' slumber was sure.

Only the shouts of his disciples, "Master, Master, we perish," awakened Jesus. Without hesitation, he "arose, and rebuked the wind and the raging of the water: and they ceased, and there was a calm," for the elements obeyed his voice. The terror of the storm passed and the wind quieted at his command. Once again earth's sun shown on the flat mirror of the sea.

"What manner of man is this! for he commandeth even the winds and water, and they obey him," his disciples exclaimed to one another. In reply, Jesus asked, "Where is your faith?" They did not answer. But they must have rejoiced upon seeing the eastern harbor and taking rest on its blissful shore. They may have even mused why they had risked their lives to come on this voyage. Was there a miracle needed in this land? So often in the presence of the

What manner of man is this! for he commandeth even the winds and water, and they obey him."

Master, they had been witnesses to his healing miracles. Perhaps they spoke of miracles that surely awaited them on this shore. Could it be an afflicted damsel, a great leader or perhaps an entire village?

It was not long before the answer appeared. "A certain man, which had devils long time, and ware no clothes, neither abode in any house, but in the tombs," came to the shoreline. When he saw Jesus among the assembled men, he fell down before the Master and cried with a loud voice, "What have I to do with thee, Jesus, thou Son of God most high? I adjure thee by God, that thou torment me not."

"What is thy name?" Jesus asked the man. The spirits possessing the man answered, "My name is Legion: for we are many." They then "besought [Jesus] much that he would not send them away out of the country." As the Master listened they spoke of a "great herd of swine feeding" on the mountainside. "Send us into the swine, that we may enter into them," they implored of Jesus. The Master had compassion and said unto Legion, "Go. And when [the evil spirits] were come out, they

went into the herd of swine." The tormented swine "ran violently down a steep place into the lake, and were choked in the sea. And they that fed the swine fled, and told it in the city, and in the country," and all that heard "went out to see what it was that was done." As for the troubled man, he was cured of his afflictions. He did not go to see the drowned swine, but did leave the shoreline. He went to Decapolis, where he spoke to those who would listen of the "great things Jesus had done for him: and all men did marvel." But not everyone received him willingly. Many came out of the village and begged Jesus "to depart from them; for they were taken with great fear." The miracle worker of Galilee consented to their wishes, for his errand of mercy that day and in that land was finished. He and his disciples entered their boat and sailed toward the familiar, distant shore.

This time as they crossed the watery deep, the sea was calm and the voyage upon the placid sea passed without incident. When they once again reached the far shore, "much people gathered unto him" bringing with them their sick and afflicted. They had waited for

"Send us into the swine, that we may enter into them," they implored of Jesus. The Master said "Go...."

his return, his healing touch, and "gladly received" the Lord. They petitioned relief from sorrows and cares, and, without reservation, relief was granted.

Among those petitioners was Jarius, a ruler of the synagogue. His sorrow was great, for his young "daughter lieth at the point of death." He "fell down at Jesus' feet, and besought him that he would come into his house," for the precarious health of his twelve-year-old child had prevented him from bringing her to the Master. Jesus agreed to follow Jarius as he led the way to the place where his daughter lay.

As the Lord walked with the leader of the synagogue, many suffering people pressed against him. In their number was a woman who had suffered for twelve years from an issue of blood. She had long since discarded traditional remedies prescribed in the Talmud—astringents, tonics, and the ritual of carrying the ashes of an ostrich egg in a linen rag. She had turned to physicians who knew how to wield a scalpel but did not recognize the painful ramifications of their deeds. The poor woman "had suffered many things of

many physicians, and had spent all that she had, and was nothing bettered, but rather grew worse."

Hoping that, "if I may touch but his clothes, I shall be whole," she "came in the press behind," as Jesus walked past. Her distance from the Master does not evidence that her longing for better heath was an afterthought. Instead it shows her keen sense of humility in the presence of the Master, the miracle worker of Galilee. Humbly, she reached forth her hand and touched his garment. When she touched him, Jesus asked, "Who touched my clothes?" When all denied, "Peter and they that were with him said, Master, the multitude throng thee and press thee, and sayest thou, Who touched me?" But Jesus' query was not to be dismissed. Although many had touched his garment, he knew that one had been healed, for "virtue had gone out of him." Only that healed individual could answer his question.

As he paused to look over the crowd, "the woman saw that she was not hid." She approached the Lord, and "trembling, and falling down before him, she declared unto him before all the people for what cause she had touched him, and how she was healed immediately." Afterward Jesus said, "Daughter, be of good comfort; thy faith hath made thee whole. Go in peace, and be whole of thy plague." And it was done.

Jesus and Jarius started again toward the home in which Jarius' daughter lay. But their footsteps were slowed by a messenger announcing to Jarius, "Thy daughter is dead." Then asked he of Jarius, "Why troublest thou the Master any further?" Neither the news of the damsel's death nor this pointed question diverted Jesus or the distraught father from continuing their course to the home. For Jesus told Jarius, "Fear not: believe only, and [thy daughter] shall be made whole."

Confidently, the two men walked past the mourners whose weeping and wailing for the loss of the young girl pierced the air. "Weep not," Jesus advised the sorrowful. "She is not dead, but sleepeth." His words, meant to comfort the sad, were turned against him for "they laughed him to scorn, knowing that she was dead." But their amusement did not stop Jesus or Jarius from entering the home where the child lay. Jesus reached for the young girl and said, "Damsel, I say unto thee, arise. And her spirit came again, and she arose straightway."

The raising of the damsel, another miracle in Galilee, may have caused the disciples to ask again, "What manner of man is this?" Not only the elements obey him, but even the dead arise at his bidding. The wind, the waters, the devils and the dead all know his voice and respond in obedience. Was the miracle

JESUS REACHED *for the young girl and said, "Damsel, I say unto thee, arise. And her spirit came again, and she arose straightway."*

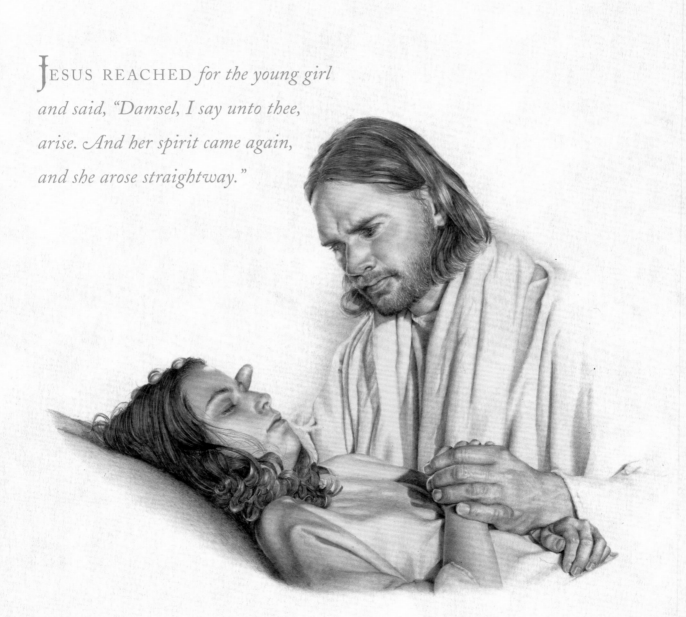

worker of Galilee the promised Messiah, the Christ, the Mighty God, or should they look for another?

Before the answer could be realized, Jesus took his disciples and departed from the well-trodden paths and fishing villages of Galilee to a "desert place apart," the secluded area of Bethsaida Julias. Perhaps he hoped to find, in the sequestered environs, a respite from the growing throng of petitioners. Yet such was not to be. When the multitude learned that Jesus no longer walked along the shoreline or the byways of Galilee, they came from near and far to the Bethsaida plains to be with him. He was their hope for a better world, a world free from pain, anguish, and suffering.

As the day wore on, Jesus healed the sick. When evening shadows cast darkness across the plain, the multitude made no attempt to leave the grassy slopes of Bethsaida, for they longed to be with their Master. Disciples of Jesus suggested that he "send them away, that they may go into the villages, and buy themselves victuals; for we are here in a desert place," a place without amenities. Although the suggestion was appropriate and logical, "Jesus said unto them, They need not depart. Give ye them to eat."

"We have no more but five loaves and two fishes," his disciples countered. This simple, peasant meal could not begin to feed the five thousand men, women, and children seated on the grassy meadow. To the amazement of his disciples, Jesus "took the five loaves and the two fishes, and looking up to heaven, he blessed them, and brake, and gave to the disciples to set before the multitude." The assembled, seated in companies and ranks of fifties and hundreds—reminiscent of an earlier day in the wilderness when Moses had organized the children of Israel—ate the peasant meal and, to the amazement of all, were filled. So full was the multitude that fragments of the meal were "gathered and placed in twelve baskets" instead of being devoured. It was not a coincidence that the extra food filled twelve baskets. The baskets were symbolic of the future work of the twelve Apostles who, in days ahead, would proclaim that a multitude in Bethsaida was miraculously fed by Jesus the Christ, the Son of Man.

This miracle, like manna from heaven in another age, was the fulfillment of a Jewish tradition. The tradition claimed that just as Moses, the deliverer from Egyptian bondage, had caused manna to fall from heaven for the children of Israel, so the true Messiah would cause manna to fall for the children of Israel once more. In feeding the multitude the meal of fishes and barley loaves, Jesus announced his advent, his true identity. Yet when the Master asked his disciples, "Whom say the people that I am?" they

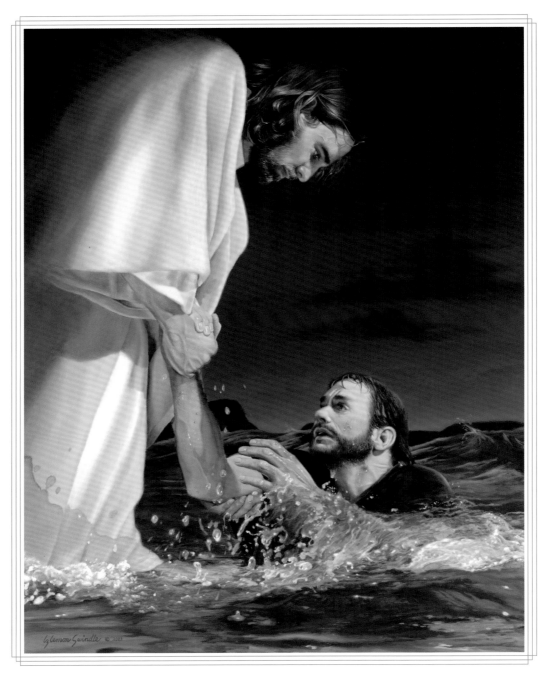

AGAINST THE WIND

answered, "John the Baptist; but some say, Elias; and others say, that one of the old prophets is risen again." The multitude which had eaten and were filled did not recognize that the man who had provided their meal was the promised Messiah.

Although they did not recognize his true identity, they wanted to crown him King of Judaea. His disciples concurred. They now looked upon him as their hope for freedom from servitude and strife. Although he spoke of the "kingdom of God, and healed them that had need of healing," they were confident that he could challenge the rule of their oppressive leaders. But Jesus refused the crown of men, for he was already the crowned King of Kings, Lord of Lords, and Prince of Peace. Did his disciples know him? "Whom say ye that I am?" he asked. It was Peter who answered, "The Christ of God."

After the revelatory declaration, "straightway Jesus constrained his disciples to get into a ship, and to go before him unto the other side, while he sent the multitudes away." In submission to his will, they complied.

Jesus, the Christ of God, "stretched forth his hand, and caught him,..."

"And when he had sent" the multitude away from the grassy slope, Jesus departed "into a mountain to pray: and when the evening was come, he was there alone. But the ship" in which his disciples had entered "was now in the midst of the sea" being tossed by the waves, "for the wind was contrary." Once again, their lives were in peril.

Jesus, after communing with his Father, was desirous to be with his toiling disciples. "In the fourth watch of the night" (meaning early in the morning of the next day) he "went unto them, walking on the sea." The disciples, who struggled to keep the boat aright "saw him walking on the sea." They cried out with fear, "It is a spirit." Jesus called to them, "Be of good cheer. It is I; be not afraid." Peter heard the familiar voice and said, "Lord, if it be thou, bid me come unto thee on the water." Jesus beckoned Peter to step upon the stormy sea and come unto him.

"And when Peter was come down out of the ship, he walked on the water, to go to Jesus," but in so doing, his faith wavered, for "when he saw the wind boisterous, he was afraid; and beginning to sink, he

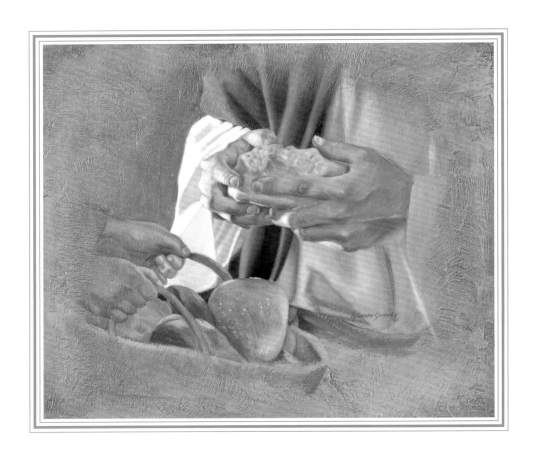

cried saying, Lord, save me." Jesus, the Christ of God, "stretched forth his hand, and caught him, and said unto him, O thou of little faith, wherefore didst thou doubt?" And when Peter and Jesus boarded the ship, "the wind ceased. Then they that were in the ship came and worshipped him, saying; Of a truth thou art the Son of God."

The events of that evening and the early morning hours—the feeding of the multitude and the walking on water—caused the disciples of Jesus to be "sore amazed." Their amazement did not cease as they reached the distant shore. Again the Master entered the villages dotting Galilee and healed all manner of diseases within. And "as many as touched him were

made whole, and he healed them all. That it might be fulfilled which was spoken by Esaias the prophet."

It seemed that nothing could halt or disrupt the healing ministry of Jesus, not element, nor water, nor evil spirits, nor death, nor, certainly, those who were blessed by his hand. Yet those who had eaten the loaves and fishes on the plains of Bethsaida were the very people at the synagogue in Capernaum, a village renowned for its grinding mills and excellent bread, who turned their heel against the Master. They refused his invitation to eat living bread and never hunger more. "I am the bread of life," Jesus had said. "He that cometh to me shall never hunger; and he that believeth on me shall never thirst. All that the Father giveth me shall come to me; and him that cometh to me I will in no wise cast out. For I came down from heaven, not to do mine own will, but the will of him that sent me." With those precious words from the Bread of Life sermon, Jesus proclaimed himself the promised Messiah.

"Is not this Jesus, the son of Joseph, whose father and mother we know? How is it then that he saith, I came down from heaven?" the people asked each other. "This is an hard saying; who can hear it?" they mused. His words, instead of unifying the Galileans

as his healing miracles had done, became the excuse for even his most ardent followers to reject him. Outward glory and material wealth were the dreams of the Galileans; Jesus spoke only of inward glory and spiritual wealth.

The antagonism that resulted from the Bread of Life sermon marked the first time that the popular opinion of Jesus waned. Former disciples sought to find truth in conflicting sects—conservative Hebraic Jews, Hellenistic Jews, communal Essenes, Pharisees, Sadducees, and Zealots—who each purported to have a superior claim on holiness. Jesus asked his chosen twelve apostles, "Will ye also go away?" Peter answered, "Lord, to whom shall we go? thou hast the words of eternal life. And we believe and are sure that thou art that Christ, the Son of the living God."

From that time forth, Jesus spoke openly to the Twelve about his ensuing death and resurrection—that he would "go unto Jerusalem, and suffer many things of the elders and chief priests and scribes, and be killed, and be raised again the third day." The disciple Peter wanted to hear nothing of this teaching and "began to rebuke him, saying, Be it far from thee, Lord." But the inevitable events that Jesus spoke of were drawing near.

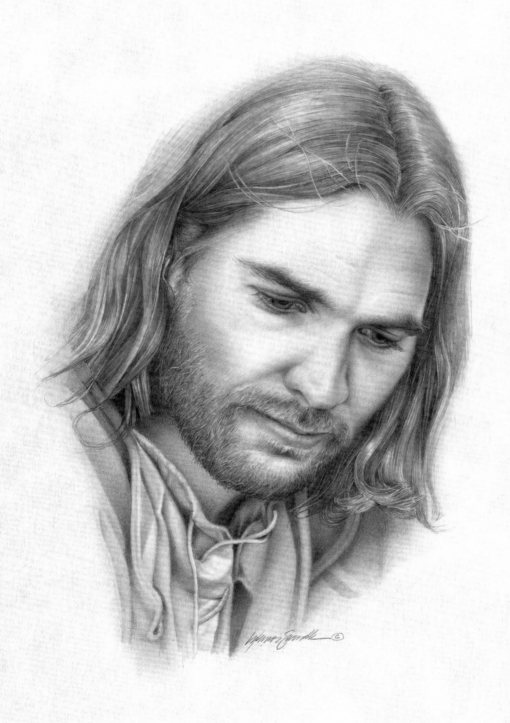

GREATER LOVE
HATH NO MAN

AS THE TIME OF his death neared, Jesus revealed several miracles to his disciples that few had dared to imagine. They had witnessed his healing of those who were physically deformed, his calming of the storm on the Sea of Galilee, and his feeding of the multitude after the Sermon on the Mount, but added dimension to his miracles became clearer to his disciples as his ministry drew to a close. ¶ Peter, the first to recognize this, asked, "Lord, how oft shall my brother sin

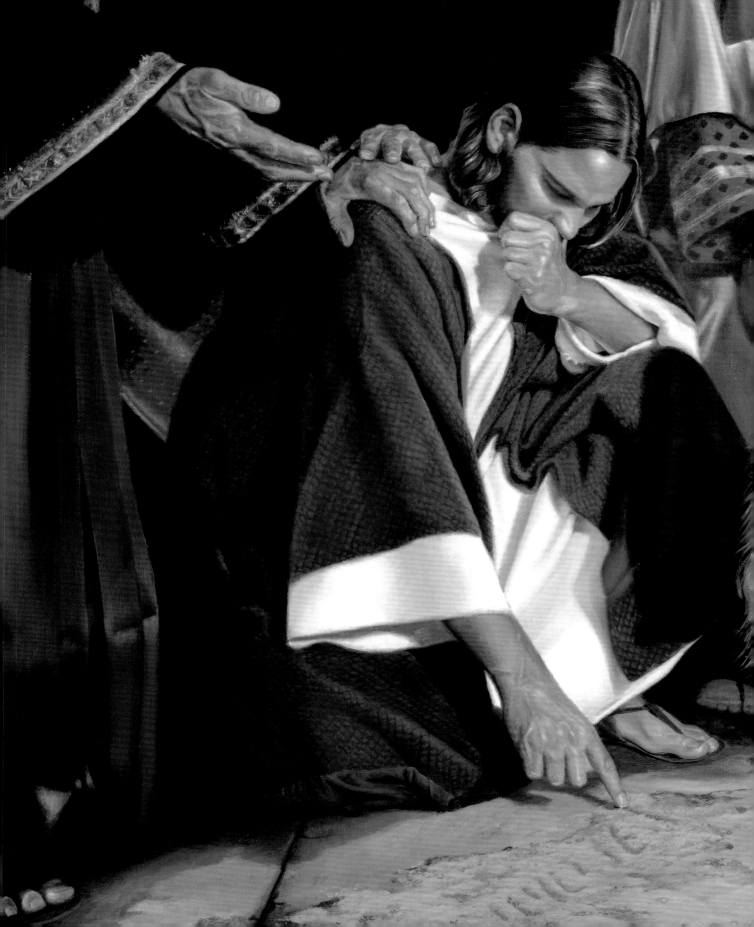

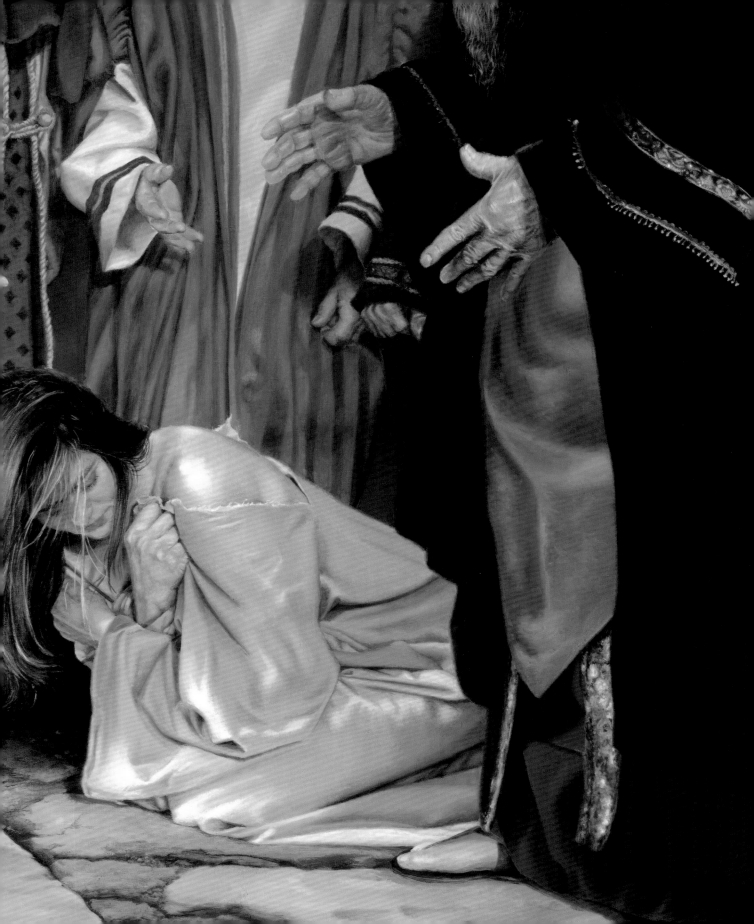

against me, and I forgive him?" The rabbis had purported that only "three offenses were to be pardoned," but Jesus replied to Peter, "Until seventy times seven." With those words, Jesus unlocked the gate that withheld forgiveness from those whose indiscretions numbered more than three. His words unleashed the blessings of inner peace for the vilest of sinners.

And his words became the underlining principle for the parable of the kingdom of heaven. In the parable, the king of heaven had a servant who failed to pay him a debt of ten thousand talents. "Lord, have patience with me, and I will pay thee all," begged the servant. Filled with compassion, the king readily forgave his servant even though his debt was great. But the servant's attitude toward forgiveness was not changed by the king's mercy toward him. "Pay me that thou owest," the servant demanded of a debtor who owed him just a hundred pence. The debtor, like the servant, asked for patience and promised, "I will pay thee all," but the servant refused. He withheld patience and cast the debtor into prison. Upon learning of his servant's unrelenting actions, the king demanded that the servant pay his past debt. Jesus, likening this parable to his disciples who were prone to withhold forgiveness, stated, "So, likewise shall my heavenly Father do also unto you, if ye from your hearts forgive not every one his brother their trespasses."

This teaching of Jesus—the miracle of forgiveness—was tested in Jerusalem, the city where pilgrim and sinner alike exclaimed, "It is better to spend one day here than a thousand days elsewhere." Jerusalem was the spiritual pinnacle, the greatest place on earth, the city named for peace, where a weary traveler could enjoy a respite from the cares of life. Among the many travelers that year in Jerusalem were Jesus and his disciples. One morning as they entered the Temple Mount located at the center of the Holy City, scribes and Pharisees noted their entry and brought before Jesus a woman taken in the very act of adultery. "Now Moses in the law commanded us, that such should be stoned," they stated. "What sayest thou?" they asked smugly, knowing that "death by stoning as the penalty for adultery" had ended centuries before and was forbidden under Roman law. If Jesus were to state that the woman should suffer death by stoning, his words would defy Roman law. If he were to conclude that she should not suffer death, his words would contradict Mosaic law.

With his finger, the Master "wrote on the ground, as though he heard them not." By writing on the ground, a symbolic act signifying his unwillingness to discuss the matter, he distanced himself from the

A "WOMAN TAKEN IN ADULTERY" *was brought before Jesus. "Now Moses in the law commanded us, that such should be stoned," her accusers stated, but then asked, "What sayest thou?" With his finger, Jesus "wrote on the ground, as though he heard them not." They asked him again and were told, "He that is without sin among you, let him first cast a stone at her." Being unclean themselves, the accusers departed. "Hath no man condemned thee?" Jesus asked the woman. "No man, Lord," she answered. Jesus said to her, "Neither do I condemn thee: go, and sin no more."*

issue. But the scribes and Pharisees ignored this act and continued to press him. Although the woman's husband, the witnesses, and the guilty man pressed no charges, the accusers did not refrain from seeking a legal opinion from Jesus. They badgered the Lord until he said, "He that is without sin among you, let him first cast a stone." Being themselves unclean, the accusers departed. Though they had so aggressively sought his opinion, they turned away, aware of their own guilt. None among them was without sin, and in light of the Savior's declaration, the woman's punishment seemed less necessary.

"Hath no man condemned thee?" Jesus asked the woman. "No man, Lord," she answered. Jesus said her, "Neither do I condemn thee: go, and sin no more." The miracle of forgiveness for that woman on that day in Jerusalem was as tangible and real as the healing of the blind and the leprous in Galilee. The miracle was as valuable to this woman as Jesus' reaching out his hand to save Peter from a watery grave and his raising the daughter of Jarius from the dead. The words of Jesus to the woman broke down the pharisaic wall that had encompassed forgiveness much like the shouts of Joshua and his men tumbled the walls surrounding Jericho.

With this healing blessing, as with all others, came the loving invitation of Jesus, "Come unto me, all ye that labour and are heavy laden, and I will give you rest. Take my yoke upon you, and learn of me; for I am meek and lowly in heart: and ye shall find rest unto your souls. For my yoke is easy, and my burden is light." Those who accepted his invitation found rest for their souls and followed the Master from Jerusalem as he sought all those in need of comfort in and outside the walls of the Holy City. Those in need—the blind, the halt, and the diseased—found rest for their souls in the healing touch of the Master and joined the growing throng of his followers. Although the new disciples hoped that Jesus would linger with them outside the walls of Jerusalem, such was not to be. News he received from faithful friends turned his thoughts and his steps once again toward the Holy City.

Mary and her sister, Martha, residing with their brother Lazarus in the small village of Bethany, sent word to Jesus when their brother fell ill. They beckoned him saying, "Lord, behold, he whom thou lovest is sick." Their concern for Lazarus, whose name means "God help him," led them to ask the Lord for divine intervention on his behalf. After receiving their urgent message, Jesus exclaimed, "This sickness is not unto death. But for the glory of God, that the Son of God might be glorified thereby." But then, countering

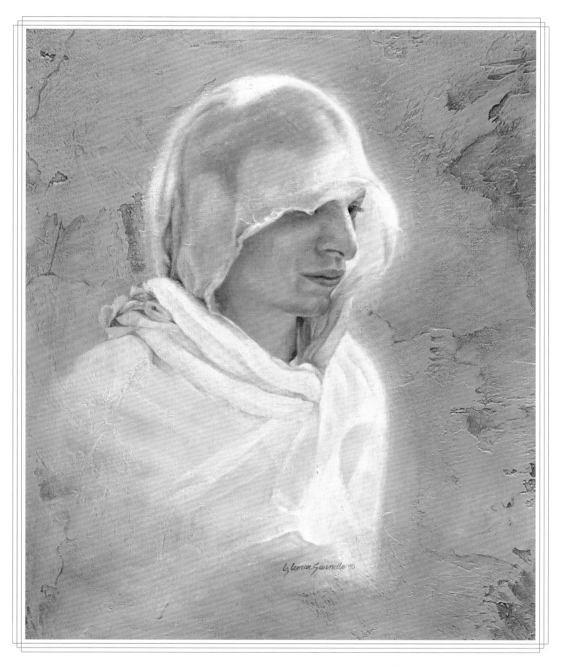

LAZARUS

his own words, Jesus announced, "Lazarus is dead." His announcement meant that he and his disciples had missed bidding farewell to a faithful friend and preparing his body for burial by packing myrrh and aloe between strips of linen to lessen death's stench. They had missed the funeral procession and had missed carrying the bier of Lazarus as a last act of kindness for him. And finally, they had failed to lament with mourners at his burial site.

Four days passed before Jesus and his disciples could reach Bethany and grieve with Mary and Martha. According to Jewish tradition, the passage of three days meant that the spirit of the deceased had departed and the body had begun to decompose. Thus, when Jesus and his disciples arrived in Bethany on the fourth day, they were too late to take part in the traditional mourning ceremonies. They were not too late, however, to witness that "many of the Jews [had come] to Martha and Mary, to comfort them concerning their brother." Noisy lamentations pierced the air that day in Bethany. Chairs and couches in the family home were

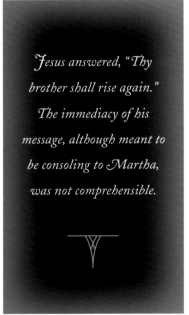

Jesus answered, "Thy brother shall rise again." The immediacy of his message, although meant to be consoling to Martha, was not comprehensible.

turned upside down, evidencing that all was not right in the dwelling. Mourners, wearing torn sackcloth as a testament of their discomfort, sat on low stools and spoke only of their sorrow and misery.

When Jesus arrived, Martha greeted him by saying, "Lord, if thou hadst been here, my brother had not died. But I know, that even now, whatsoever thou wilt ask of God, God will give to thee." Jesus answered, "Thy brother shall rise again." The immediacy of his message, although meant to be consoling to Martha, was not comprehensible. "I know that he shall rise again in the resurrection at the last day," Martha replied. She did not understand that on this day she would see her brother walk again among men.

"Where have ye laid him?" Jesus asked. "Lord come and see," he was answered. Following the grief-stricken woman to the burial site outside the village, Jesus came to where Lazarus had been laid, "a cave, and a stone lay upon it." He requested that the stone be removed. Martha resisted his request replying, "Lord, by this time he stinketh: for he hath been dead

four days." Jesus said to Martha, "If thou wouldest believe, thou shouldest see the glory of God." Wanting to believe, she had the stone rolled away.

The raising of Lazarus from the dead caused many who had wondered about the true identity of Jesus to believe that he was the promised Messiah. They no longer looked for another to be the Christ, the Holy One, the Son of God. To them, Jesus, the miracle worker of Galilee, was the Son of Man.

Such belief was not shared by the scribes and Pharisees. They belittled the miraculous, unexplainable events that had transpired before their eyes. Instead of humbly recognizing the divinity in Jesus, they took counsel one with another about possible problems that might arise if Jesus were allowed to continue his miracles. "What do we?" they asked. "This man doeth many miracles. If we let him thus alone, all men will believe on him: and the Romans shall come and take away both our place and nation."

The question they posed was not answered by humble petition to the throne of God. It was the selfish reasoning of man that prevailed that day in the holy city of Jerusalem. Such reasoning, by men who knew better, led to the conclusion that the miracles of Jesus had seduced gullible Galileans then spread to others in Bethany and the surrounding environs. If Jesus' movements were not stopped, rebellion would be the outcome. "It is expedient for us, that one man should die for the people," said the High Priest Joseph Caiaphas. He reasoned that the death of Jesus would prevent "the whole nation" from perishing. And "from that day forth," the Jewish leaders counseled "together for to put [Jesus] to death."

To avoid the evil plots of the learned men and civic leaders, Jesus left the mounting malice in Jerusalem to journey to Ephraim and from there to the coasts of Judaea beyond Jordan. But he was not gone long from Jerusalem. He knew the troubles that awaited him in the Holy City. Yet his time was at hand; Passover was near, and with that holy week would come a miracle of healing that would surpass all understanding. The miracle prophesied by Isaiah was near: "All we like sheep have gone astray; we have turned every one to his own way; and the

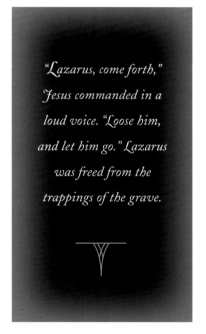

"Lazarus, come forth," Jesus commanded in a loud voice. "Loose him, and let him go." Lazarus was freed from the trappings of the grave.

Lord hath laid on him the iniquity of us all. . . . Surely he hath borne our griefs, and carried our sorrows." The miracle of atonement in which Jesus would offer himself as a sacrificial lamb was just days away. Days in which Jesus needed to prepare himself for the ultimate test of his teachings on forgiveness.

Those days spent in Jerusalem were crowded days, days in which thousands of pilgrims walked the streets of the Holy City, unaware of the events about to unfold. These pilgrims, dressed in festive white, were looking forward to being greeted as long-time friends by fellow worshippers. Curtains hung over doorways suggested to passersby the hospitality awaiting them within. Strangers were freely offered bed and board, a loan of domestic animals for sacrifice, and a room to eat a Pascal lamb. This was Passover week, a joyous reunion for Israelites from near and far.

But Jesus knew that this Passover week was different than all others. It was the week that generations throughout time would speak of with reverence. For this week—the week of his atoning sacrifice—would forever change the course of humanity. "Behold, we go up to Jerusalem," he said to his disciples. "The Son of man shall be betrayed unto the chief priests and unto the scribes, and they shall condemn him to death." But such words of ominous foreboding seemed unwarranted to his disciples, for when Jesus entered the Holy City, he was greeted as King of the Jews: "A very great multitude spread their garments in the way; others cut down branches from the trees, and strawed them in the way." Pilgrims greeted him with shouts of "Hosanna to the Son of David."

Although his entry into the Holy City was joyous, Jesus knew such shouts of praise would soon be silent. The slaughter of the Pascal lambs neared and with it the sacrificial miracle of the Savior. All that remained was one last Passover feast with his apostles, this time in a large chamber in a choice, secluded setting. Peter and John and the good man of the house prepared the chamber and the feast for the festive occasion. The lamb was roasted on a pomegranate spit, lamps were lit, unleavened cakes baked, bitter herbs prepared, and the room made festive.

Although the apostles who entered the room may have supposed that the conversation at this Passover feast would commemorate the merciful deliverance of their forebears from oppressive Egyptian servitude, this Passover, the final Passover, would break with tradition. "Now when the even was come, [Jesus] sat down with the twelve" in the upper room. He said to them, "With desire I have desired to eat this with you before I suffer." After Judas Iscariot left the upper

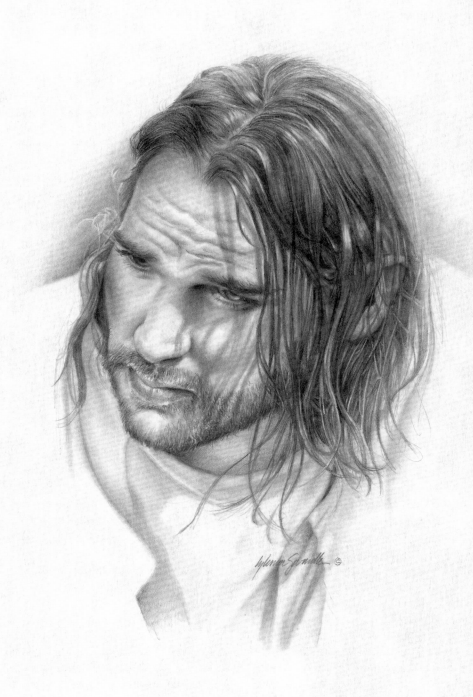

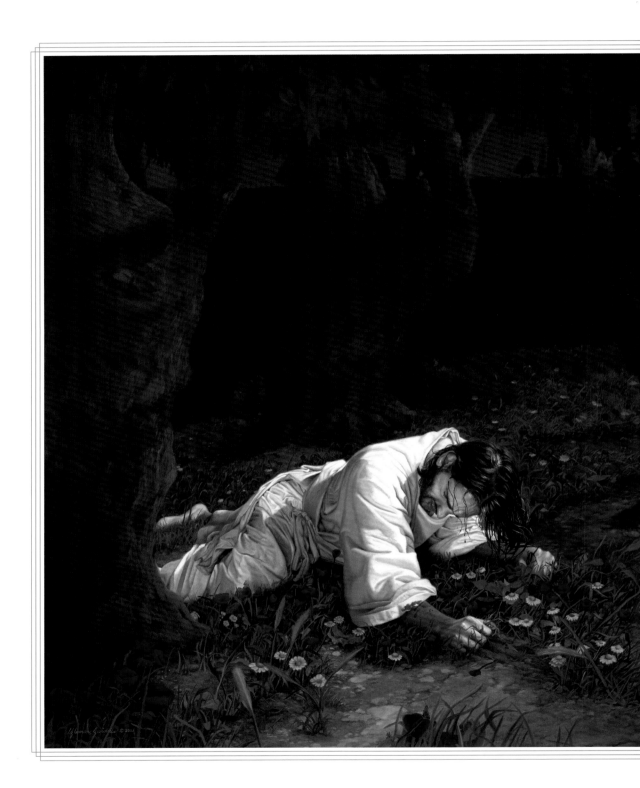

room, Jesus took the round unleavened bread and "blessed it, and brake it, and gave it to the disciples, and said, Take, eat; this is my body" or as Luke reports, "This do in remembrance of me." He then "took the cup, and gave thanks, and gave it to them, saying, Drink ye all of it; For this is my blood of the new testament, which is shed for many for the remission of sins." With this act, he signaled the miracle of his atoning sacrifice in which he would bleed from every pore as a ransom for the sins of the world. His testament or witness of these futuristic events was sure. Although his disciples drank from the cup, it was not until Gethsemane that they began to understand his sacramental words.

But Jesus' promise of comfort to them was understood. "Peace I leave with you, my peace I give unto you: not as the world giveth, give I unto you. Let not your heart be troubled, neither let it be afraid," Jesus said. He then pronounced a new commandment "that ye love one another; as I have loved you, that ye also love one another. By this shall all men know that ye are my disciples, if ye have love one to another." Realizing that his words had farewell overtones, Peter said, "Lord, whither goest thou?" Jesus answered his apostle, "Whither I go, thou canst not follow me now; but thou shalt follow me afterwards. …the hour cometh, yea, is now come, that ye

GETHSEMANE

Fig Leaves

shall be scattered, every man to his own, and shall leave me alone: and yet I am not alone, because the Father is with me." Then lifting his eyes heavenward, Jesus prayed, "Father, the hour is come; glorify thy Son, that thy Son also may glorify thee. …I pray not for the world, but for them which thou hast given me."

After the prayer, with faithful apostles by his side, Jesus departed from the upper room, crossed the Kidron Valley, and climbed up the slope of Mount Olivet to the olive orchard known as Gethsemane. (Gethsemane means "oil press.") Most notable in the Garden of Gethsemane were gnarled olive trees that had, with little care, thrived and produced fruit for centuries, even during long periods of drought.

These ancient trees contrasted with the fig tree Jesus had cursed in Jerusalem as "having leaves," but devoid of fruit. The fig tree's leafy facade gave the appearance of having born fruit, but instead of seeing kermouses, or fruit, hidden under the broad leaves, there was no indication of life. "No man eat fruit of thee hereafter for ever," said Jesus as he cursed that tree. Symbolically his words represented the Lord's anger with the rebellious and unbelieving in the Holy City: "O Jerusalem, Jerusalem, thou that killest the prophets, and stonest them which are sent unto thee, how often would I have gathered thy children together, even as a hen gathereth her chickens under her wings, and ye would not!" The olive trees that night in the garden contrasted greatly with the fig tree and the hen. For the olive trees had been fruitful and its fruit in the presses of Gethsemane had provided needed oil to sooth the wounds of the children of the House of Israel for generations.

Turning to his apostles, Jesus said, "All ye shall be offended because of me this night: for it is written, I will smite the shepherd, and the sheep of the flock shall be scattered abroad." In that statement, Jesus announced to his apostles that he was the shepherd and they were his flock that would soon scatter. Peter attempted to assure the Lord of his faithful devotion and his willingness to stand by the Master even in peril. He said, "Though all men shall be offended because of thee, yet will I never be offended." But the Master knew better. "Before the cock crow, thou shalt deny me thrice," he said. He then directed his disciples, "Sit ye here, while I go and pray yonder."

He took only Peter, James, and John with him into a secluded area of the garden. There under spring skies and near the ancient olive trees, Jesus became sorrowful and weighed down. "My soul is exceeding sorrowful, even unto death: tarry ye here, and watch with me," he said to Peter and the sons of Zebedee.

For this was the night of nights, the night in which his unfailing love for all the generations of mankind would be tested. Just as the heavy stone of the oil press crushed the olives to provide consecrated oil to heal the sick, so the heavy burden of the sins and sorrows of the world would press upon Jesus this night to grant healing for all the sick throughout time.

Knowing something of the agony in the miracle that awaited him, he went alone "about a stone's cast," or a hundred feet away, from his apostles and "fell on his face, and prayed, saying, O my Father, if it be possible, let this cup pass from me: nevertheless not as I will, but as thou wilt. My soul troubled; and what shall I say? Father, save me from this hour: but for this cause came I unto this hour." This was the appointed hour for which Jesus had come into the world, the hour that the angel of the Lord had spoken of years before to Joseph the carpenter: "Thou shalt call his name Jesus; for he shall save his people from their sins." He must not fail, and he would not! For this very hour he was born and for this hour he had lived.

There is nothing to compare to the mystery of redemption that night in the Garden of Gethsemane. Finite minds cannot comprehend how Jesus ransomed himself for the redemption of all. But they do know

AND THERE *appeared an angel unto him from heaven, strengthening him*

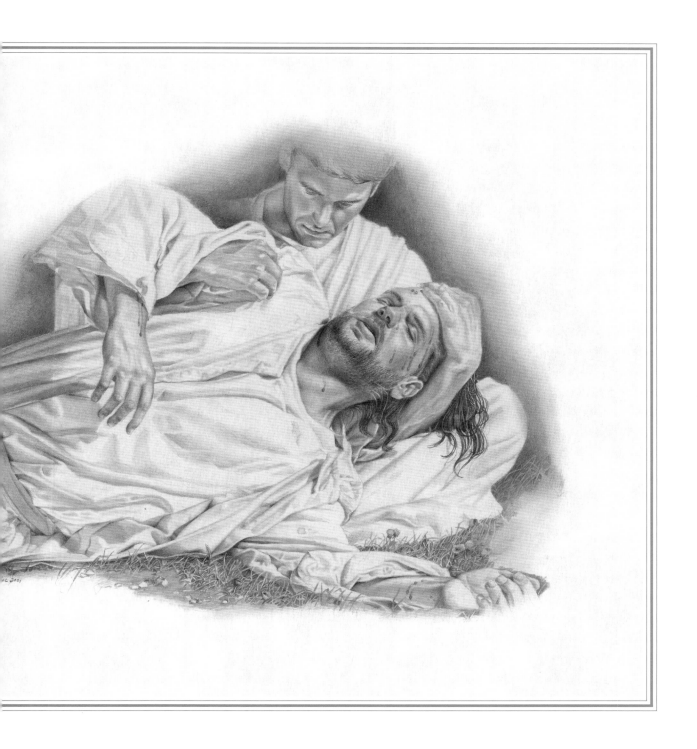

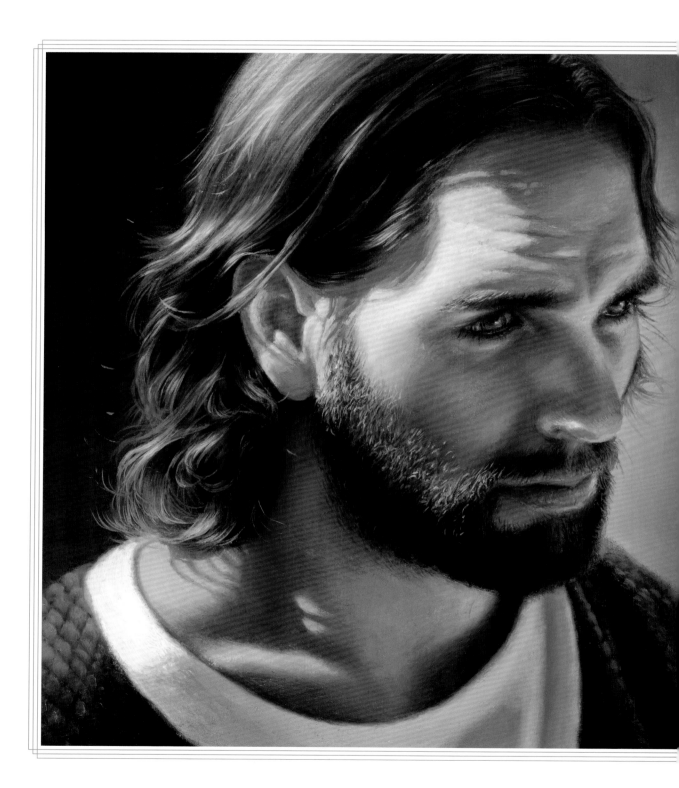

that in that garden, hallowed by his sacrifice, Jesus "descended below all things as he prepared himself to rise above them all." The Savior "suffered the pain of all men, that all men might repent and come unto him." In Gethsemane, the King of Kings became the meek and lowly one in the darkness of that night as he exclaimed, "Thy will, O Lord, be done."

On that night of nights, his precious blood was freely spilt. His sinless sacrifice for the souls of mankind was freely given. Yet during his extremity, when every pore of his body bled, Jesus' closest disciples slept, unaware that they were missing the greatest miracle of all, the miracle of redemption. When the atoning Savior returned to Peter, James, and John and found them sleeping, he said to Peter, "Simon, sleepest thou? couldest not thou watch one hour? Watch ye and pray, lest ye enter into temptation. The spirit truly is ready, but the flesh is weak."

A second time, Jesus distanced himself from the apostles and prayed, saying, "O my Father, if this cup may not pass away from me, except I drink it, thy will be done." The Lord's will was done and Jesus atoned for the sins of mankind and by his unselfish act showed that "greater love hath no man." Glory be to God that Jesus accepted the bitter cup that night in the Garden of

PRINCE OF PEACE

Gethsemane and became our Savior, our Redeemer and our Deliverer.

"Then cometh he to his disciples, and saith unto them, Sleep on now, and take your rest: behold, the hour is at hand, and the Son of Man is betrayed into the hands of sinners." Jesus knew that more tests of his loving nature awaited; a wooden cross and death beckoned. But he also knew that after the cross and death came the beautiful morning of the resurrection.

Dear readers, lift up your hearts in praise to God. Let your rejoicing never cease. Though tribulations may rage abroad, may the miracle Jesus wrought that night comfort you with a peace that surpasses all understanding. He is the Wonderful, Counselor, the Mighty God, the Savior of us all. The miracles of Jesus, from the changing of water into wine to the morn of his resurrection, testify that he lives and that he loves us. Join with us in praise of his holy name.